Obscene Interiors

Hardcore Amateur Décor

Justin Jorgensen

Foreword By
Todd Oldham

Baby Tattoo Books

The internet has created a forum where everyday people can publicly
expose their bodies and homes through amateur portrait photography
posted online for all to see. Justin Jorgensen has assembled a collection
of these images from the Internet and artfully adapted and edited each of
the images in order to offer his critique, not of the individuals (who have
been transformed by the author into anonymous silhouettes), but of the
environments within which they chose to exhibit themselves.

Design by Justin Jorgensen
Edited by Lauren Saraphan
Prepress by eric@pixelectomy.com

Dedicated to Dad. Heaven only knows what you'd make of this.

For their generous assistance with this project I would like to thank:
Izzi Jorgensen, David Mason, Kyle Barnes, Mary Blankenburg,
Charles Phoenix, Greg MacLaurin, Matt Taylor, Alex Alexander,
Angee Hagen, Aryca Myers, Hersch Knapp, MK Haley,
Deborah Gregory, and Steve Beyer.

ISBN: 0-9729388-0-X

Library of Congress Control Number: 2003114850

First Edition
10 9 8 7 6 5 4 3 2 1

Manufactured in China

Published by Baby Tattoo Books
6045 Longridge Avenue
Van Nuys, California 91401
www.babytattoo.com

Introduction

Ever since naked cavemen covered their dreary walls with colorful finger paintings, men have faced an aesthetic challenge. How do we create a space that communicates our ideals of masculinity while simultaneously storing our possessions and displaying our interests? How do we make that same space appeal to our mates? In other words, how do we decorate? The answer: not very well.

Technology has evolved dramatically since we learned to walk erect, but our sense of style hasn't. This is candidly demonstrated in the following collection of amateur male boudoir photos and online personal ad pictures. Regardless of the original intent, I've obscured the often-nude figures so we can better focus on the matter at hand, the décor.

As someone who is concerned for the aesthetic future of mankind, I simply must comment on these "obscene interiors" as examples of what we should and shouldn't be doing in our homes. I know we can do better. Of course, this whole decorating discourse is only my opinion. The issue of taste is never black and white, in-between there are a million shades of gray.

Foreword

In a world of simultaneous exposure and homogenized ideas, it is most rare that we are blessed with a brave new art form as dazzling as domestic exhibitionism. Revealing in far richer ways than its original intent, we now have a peephole into the psyche (or is it psychosis?) of the everyman.

What are we to learn from Justin Jorgensen's immaculately edited collection of obscene interiors? Well, to start, we appear to be a nation of knickknack abusers. We now know dusty pink and teal green, two saddish colors, when combined create a visual apocalypse. As evidenced in almost every photo, we have tragic spatial issues when it comes to hanging art and objects. Clearly, we seem to be more confident in our roles as accumulators instead of decorators.

I'm most thankful for all this inspiring art. My imagination is far more enlivened when looking at these photos than those of polished, finely tuned interiors. I would gladly take a tour of "Obscene Interiors" any day, over a tour of the White House. Thankfully, Justin has made it just that easy for us. Enjoy the tour and happy decorating!

Todd Oldham

The Interiors

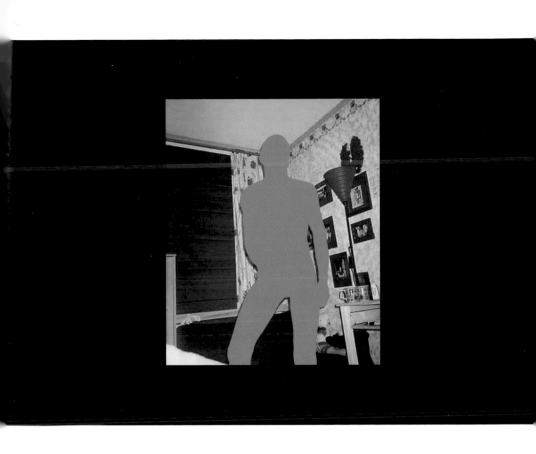

First of all, cheap is not a color scheme.

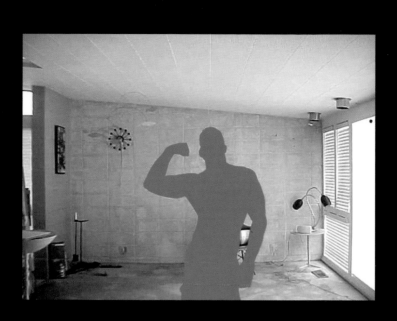

Before you start decorating it's important to listen
to the empty space. Architectural details, materials,
and even the layout can tell you what period or
theme it wants to be. This room is whispering,
"I can be fun, funky, and retro." But I'm not sure
anyone is listening.

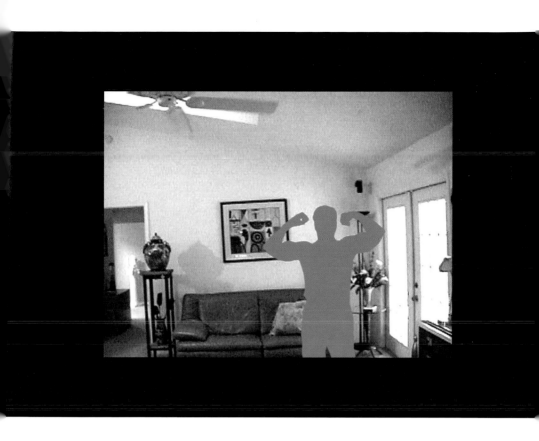

When planning a room it's important to consider how people will move through the space. Here, an urn has been precariously positioned on a teetering stand near a high traffic doorway. It's like someone is just waiting to yell, "You break it-you buy it!"

Out with the mold and in with the new! Cracks, rips, tears, dirt, discoloration, and a foul odor are all signs it's time for a change.

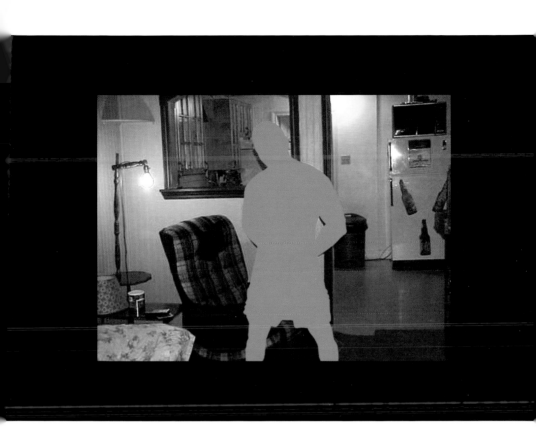

It's a clever idea to clearly label where you keep your beer with giant pictograms. It'll save your friends the hassle of searching between the cushions, under the rugs, and inside the lampshades next time they want a drink.

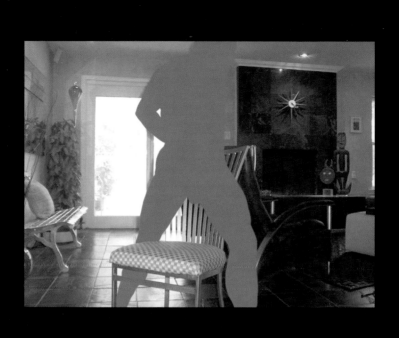

If you're looking to start a serious relationship,
decorate with live plants like that healthy Arrowhead
Vine in the corner. Fake dust-covered plants say,
"I can't handle any responsibilities whatsoever."

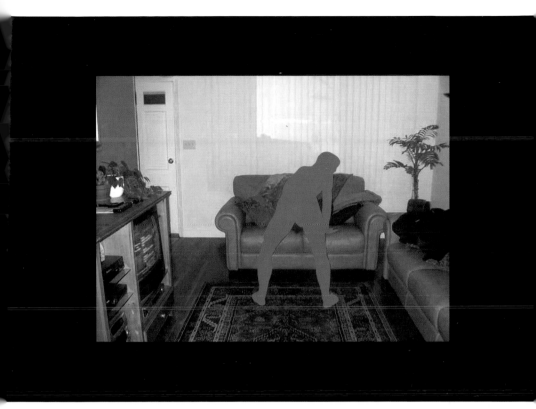

Sometimes you need something really big to fill up your space. I'd like to put a large Ficus tree in that empty area. I know it can feel strange at first having something so big inside, but if you relax you'll learn to love it.

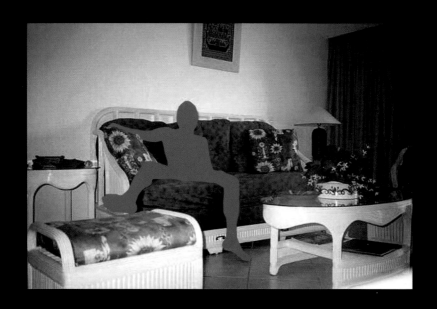

There are sunflowers on the pillows, it's like I'm on a farm – but everything is sterile white, like I'm in a hospital – and how does that folksy wall hanging fit in? Where the hell am I?

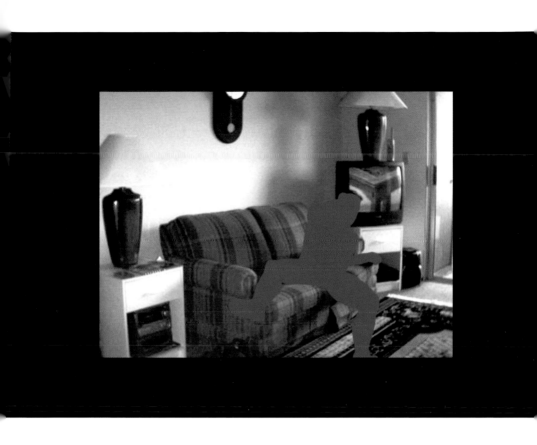

W hen Mom told us not to watch TV without having a light on, she didn't mean *on* the TV! It's as silly as putting a blender on your computer. Some things are not stackable.

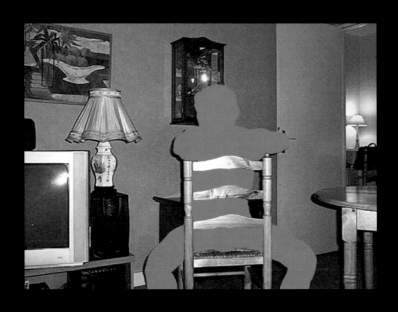

No – you shouldn't put lamps on your speakers either!

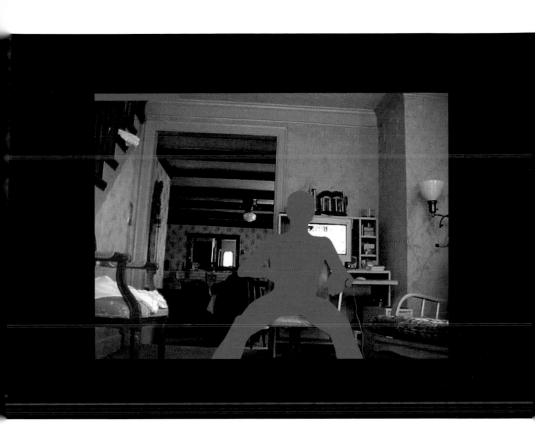

Most people try to create feelings of happiness or serenity when they choose their interior color schemes. However, this combination of "Peptic Pink" and "Phlegm Pastel" simply makes me feel nauseous.

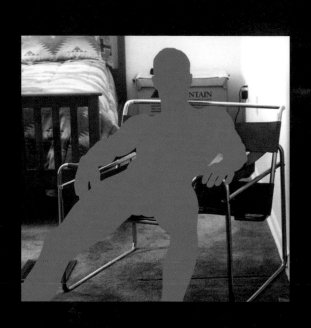

Okay, if you have the good sense to own a classic leather and chrome Wassily chair, why-oh-why would you use a cardboard box for a nightstand?

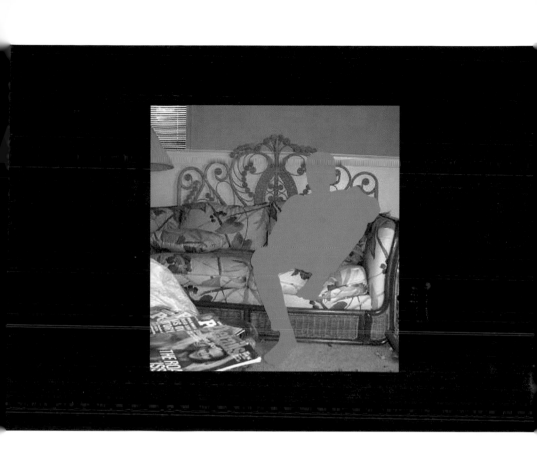

Something wicker this way comes!

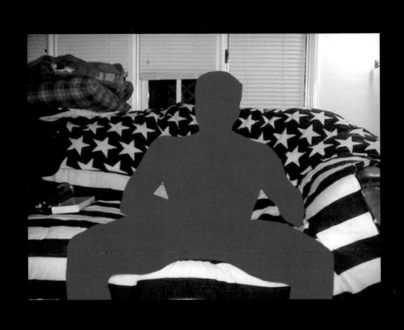

"Old Glory" as a sofa slipcover? What is so
special about this couch that it needs to be literally
protected under the American flag? I can't figure it
out. Is the sofa seeking aesthetic amnesty?

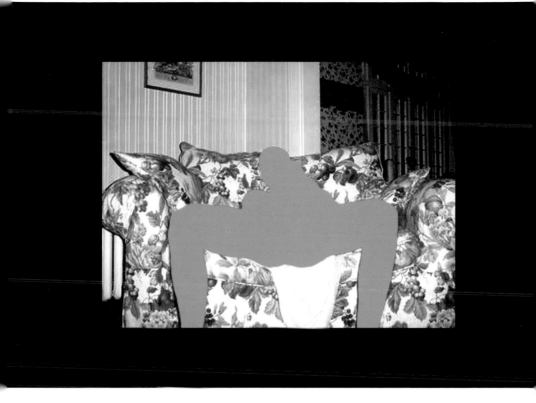

This makes me hungry for ambrosia salad – the old
fashioned kind with mandarin orange wedges, mini-
marshmallows, pineapple rings, and magenta
maraschino cherries suspended in that whipped
cream stuff.

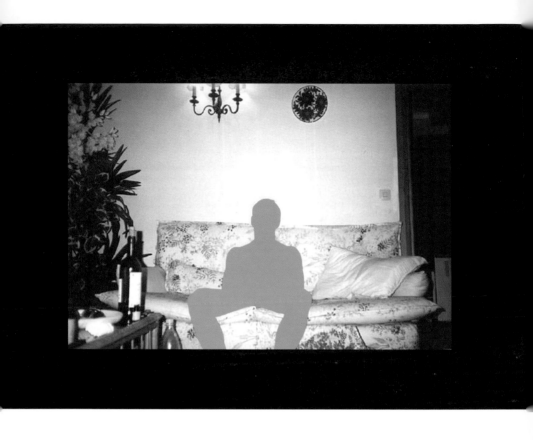

That couch would look totally great if it was on fire being thrown from a bridge.

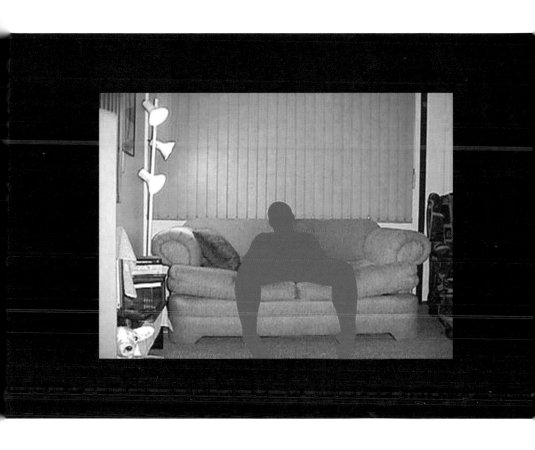

If you're going to spotlight a boring sofa like this you'd better jazz it up first. Darken in the front ends of the armrests to look like cartoon eyes, add some felt teeth under the cushions, and call it Grouchy the Couchy. Tell your friends he eats pocket change and sometimes the TV remote.

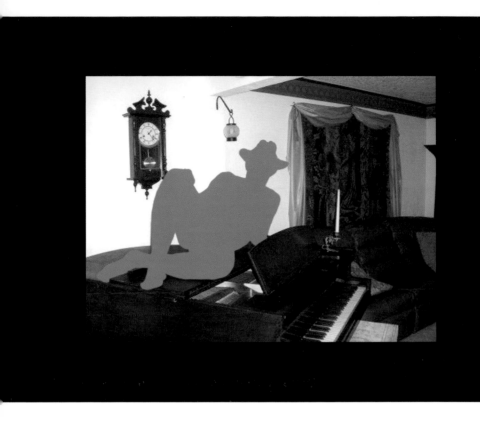

I have a hunch why the piano is out of tune – but
what's the excuse for this dismal room hitting such
a sour note?

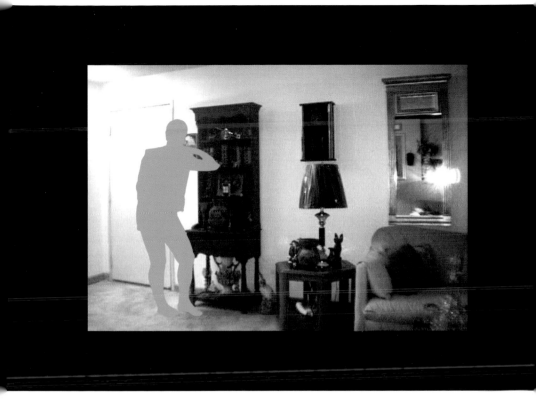

Sometimes people confuse "pretty" with "shitty," a problem I can't understand because the two looks seem very different to me.

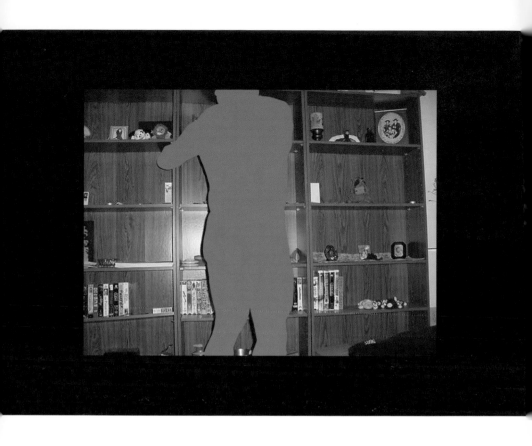

Here's a tip: Don't install shelving units if you can't successfully fill them. Family photos and souvenirs are important, but these are all so small and poorly arranged it's depressing. It's like someone with a bad speech impediment trying to say, "I love you." The emotion is there, but the delivery gets in the way. It almost makes me cry.

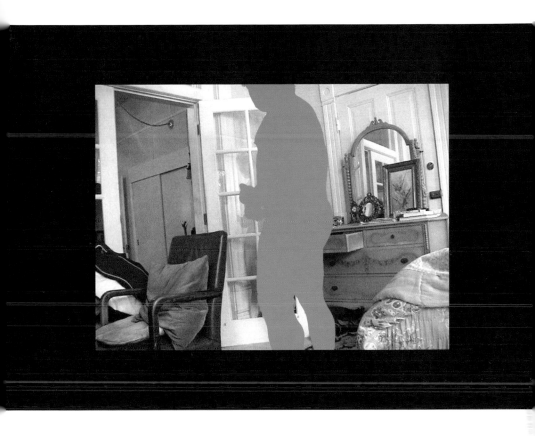

Antique vanities are terrific for pulling in front of a
door when zombie vampires are trying to break in. But
I can't imagine anyone wanting to invade this mess;
breaking out seems more likely. Which leads me to
wonder, just who is barricaded behind that closet door?
My guess: a zombie vampire cleaning lady.

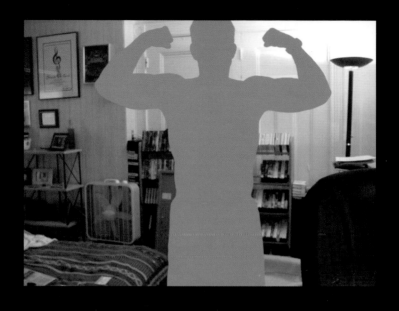

I had two of these wildly popular $12 Home Depot lamps. A real bargain, but when you turn up the 300-watt halogen bulbs your room will get really toasty. That explains the fan.

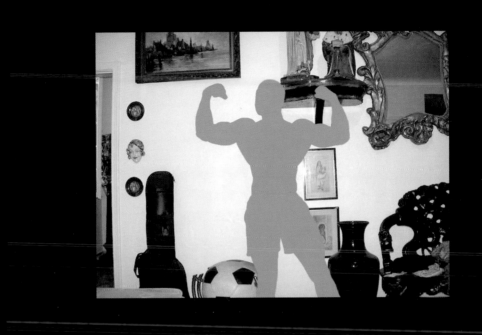

There's more mystery behind this bizarre collection than a game of Clue. "It was Prof. Plum, in the hall, with the giant soccer ball!"

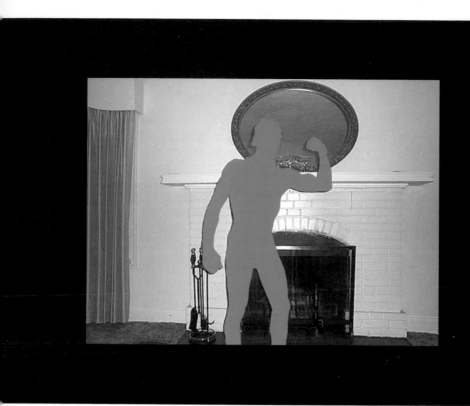

Bleak, lifeless, and white, white, white. Why, it's a color scheme inspired by a North Dakota January.

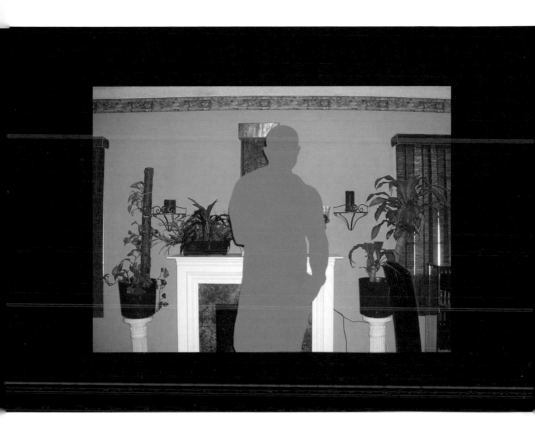

I know these plants would look retarded if you just set them on the floor, but they look *way* retarded balancing on these tiny columns. Just get big plants! Currently, these two look like short top-heavy girls desperately strapped into platforms.

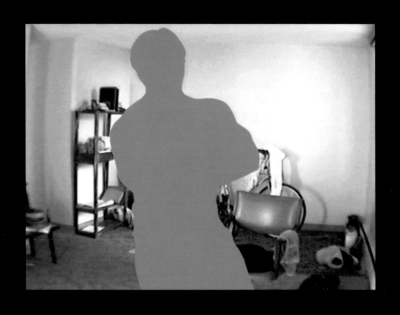

Sometimes men try to prove their masculinity by
not even attempting anything that could be
considered decorating.

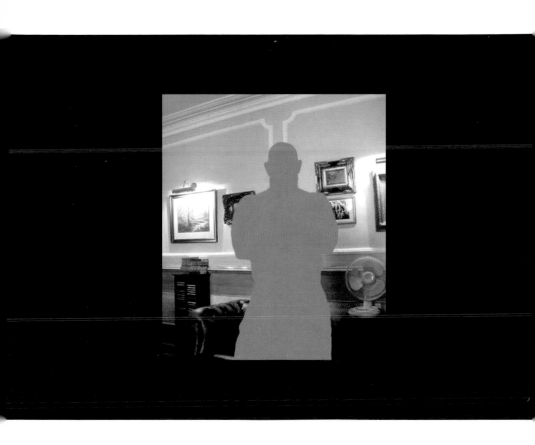

Clearly some effort and intelligence went into this elegant gallery. But, the devil is in the details, and that plastic drug-store fan blows it all to hell.

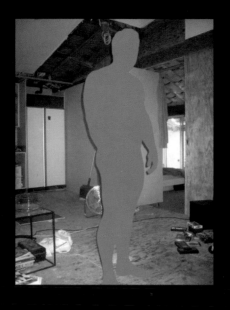

This is the sort of brute lifestyle men pretend to love. No need for sissy stuff like ceilings or walls. It's interiors "au natural." I mean, I like the look of raw wood too, but living with a bunch of exposed studs seems sort of queer.

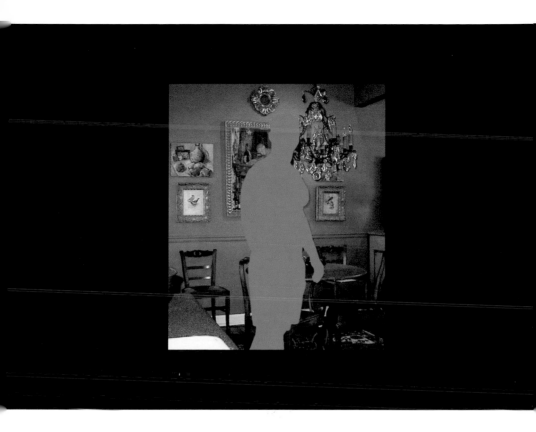

Lots of people are afraid of dark colors because
they think it'll make their rooms seem smaller. I say,
"So what?" Sometimes you want to be in a small dark
cave-like room. Like when you're recovering from a
hangover, a bad breakup, or both.

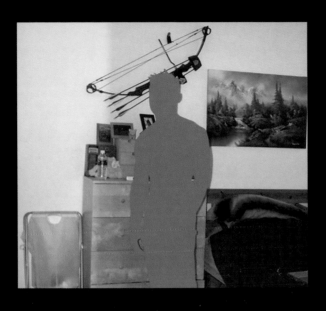

I can't recommend displaying hunting gear in your boudoir. I find talk of killing animals doesn't make for great foreplay.

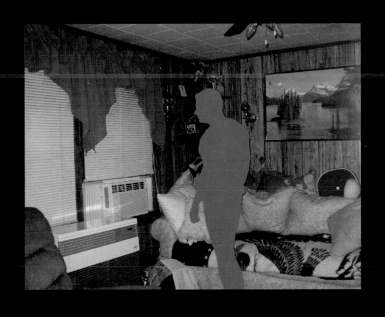

Someone made a wrong turn on their way to "Marlboro Country" and ended up in "Fugly Gulch."

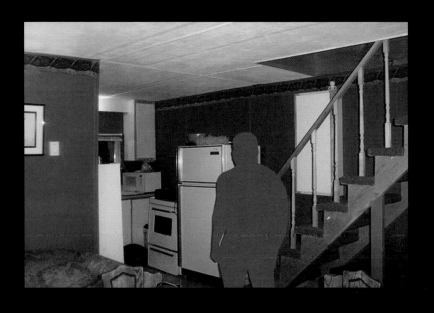

It looks like you could really hit your head coming down those stairs. Maybe that explains how a maroon and gold border got combined with bright aqua walls.

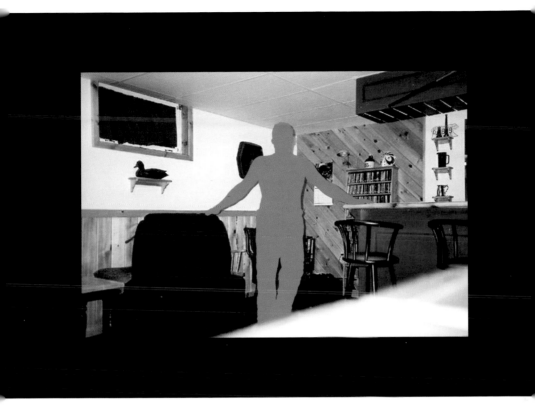

If that duck decoy were one of those novelty telephones this would be sublime suburban kitsch, the antithesis of chic uptown nightlife. I bet this idea will catch on and you'll be seeing hot new clubs themed after Dad's basement barroom filled with bawdy faux-nostalgia from "The Lighter Side" catalog. I can see it now, Ian Schrager's new haute spot "Bronx Cheer!"

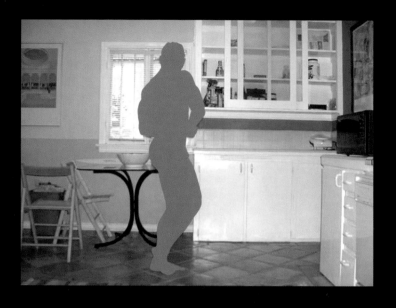

This is not so bad really, but what a missed opportunity with the sliding glass cupboard doors. It's the perfect place for a display of quirky food ephemera, like boxes of "Mr. T" cereal and packets of "Funny Face" drink mix. After all, what's a kitchen without kitsch?

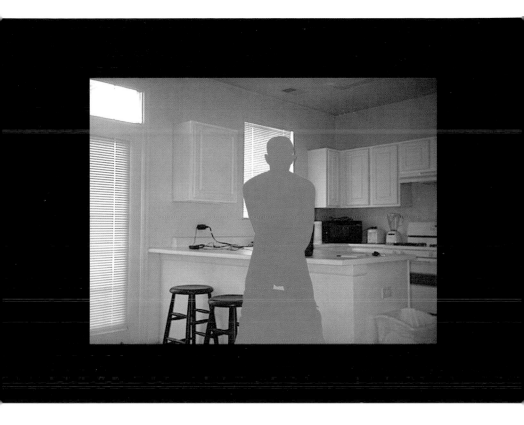

Someday, the owner will overcompensate for this colorless kitchen with the worst "Tiki" theme you've ever seen. It'll start with a call to a home makeover show and end when the citronella candles ignite the plastic thatch they hot glued to the ceiling. It's coming. I just know it.

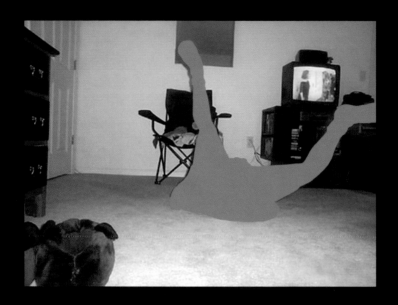

The great thing about collapsible furniture like that chair in the background is that you can fold it up, fit it in a trashcan, and still have room for other garbage.

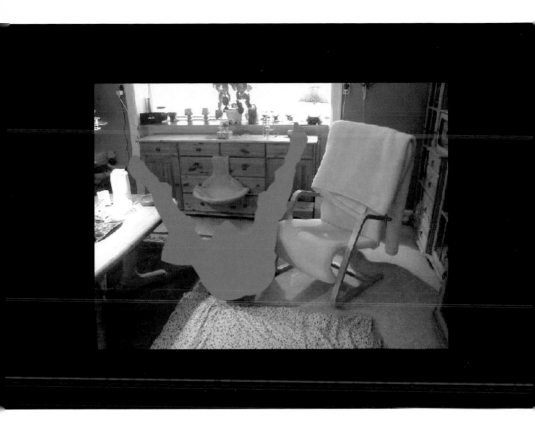

M odern Danish furniture can be so well crafted. It looks deceptively light but is actually very solid and sturdy.

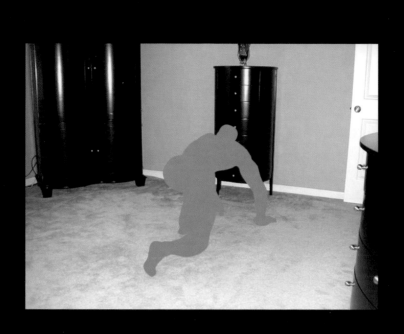

The problem with a fetish for designer furnishings
is before you know it, you've blown your budget and
you don't even have a place to sit.

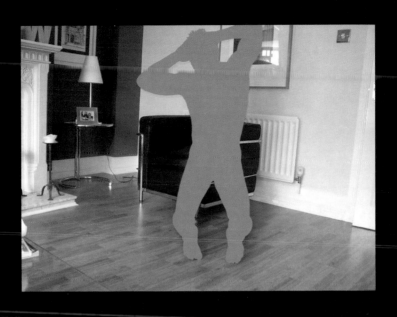

This leather Le Corbusier is hot, and I don't mean in a good way, it's way too close to the radiator! Also, don't hang quality art over a heat source, put a Thomas Kinkade there instead.

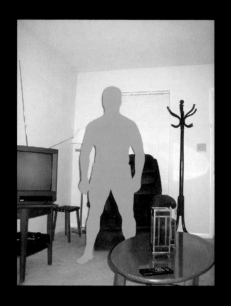

T his is unsettling – very "Twilight Zone." It's like space aliens built a diorama of what they believe a human habitat looks like for their inter-galactic natural history museum.

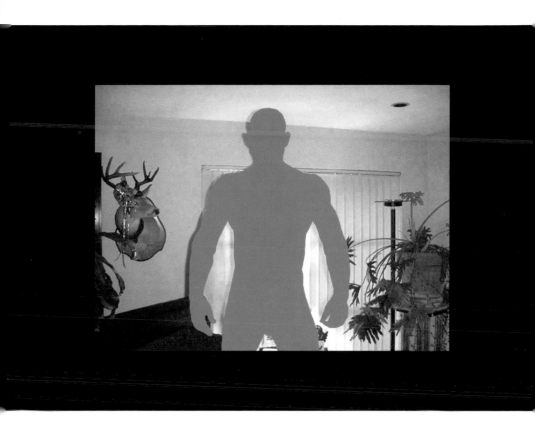

W hat a fine specimen! I hope Santa can still make
all his deliveries with the remaining seven.

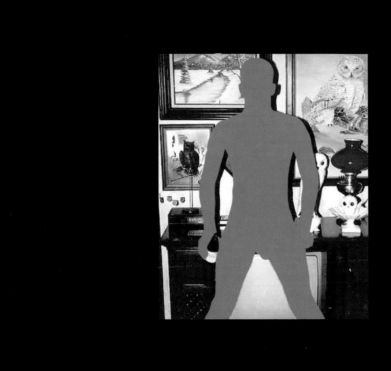

Give a hoot – don't pollute…your interiors.

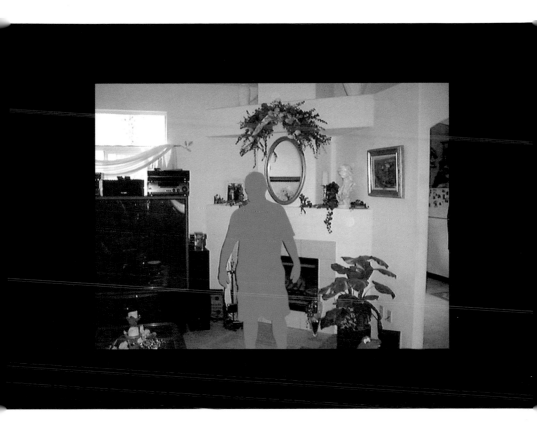

I'd love to know which tract-home architect is responsible for the mess of shapes over the fireplace. And, who blocked the picture window view with an enormous television? It's a total aesthetic disaster. I wish I had a book on Feng Shui to slap someone in the face with.

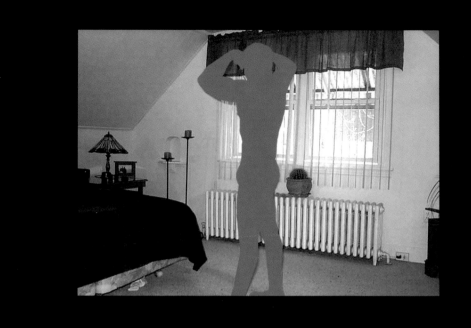

Dios mio! I know it's a Barrel Cactus and it lives in the desert, but that doesn't mean it'll survive on a radiator.

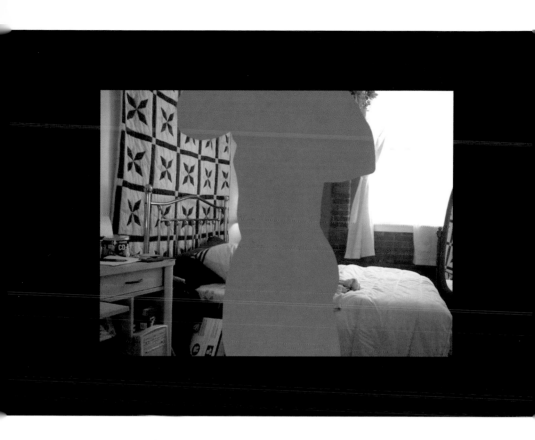

If you live in an apartment, hanging a quilt or a rug on the wall is a simple and decorative way to help sound-proof your bedroom. Let Grandma's hard work dampen the sound of yours.

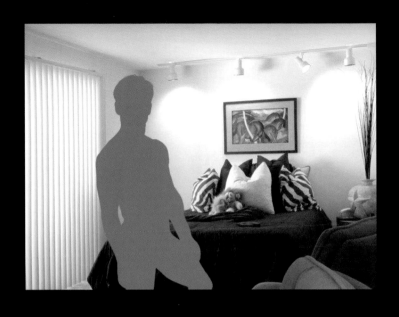

You have to be careful with artful pillow arrangements. Some guests will just timidly stand there thinking, "Oh, I'd hate to mess up the pillows you spent all morning on. Let's just cuddle on the couch instead."

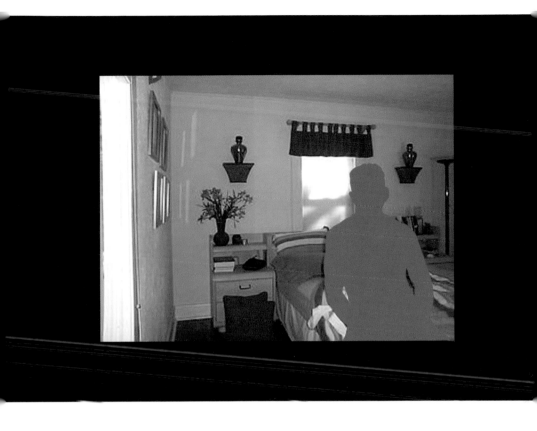

I believe it was Marilyn Monroe who'd look in the mirror before leaving her home and remove the first item that caught her eye, i.e. an earring, a broach, whatever. The point being you want people's eyes on you, not distracted by some knick-knack or bauble. So please, someone, get rid of those dark little vases and those dark little shelves they're planted on because I won't be able to criticize the rest of the room until they're gone.

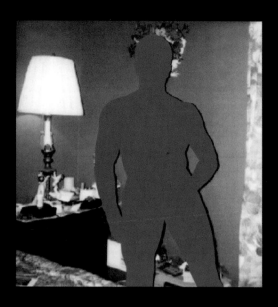

If you plan on entertaining in your bedroom choose wall colors and bedding that compliment your skin tone. You may love "Orchid Bang-bang" in the paint store, but it may not love you at home. So, before you pick a color, go out and shoot test Polaroids of yourself standing naked in front of different colored walls and see what works. You'll want to be totally sure you've found the perfect color before you're committed.

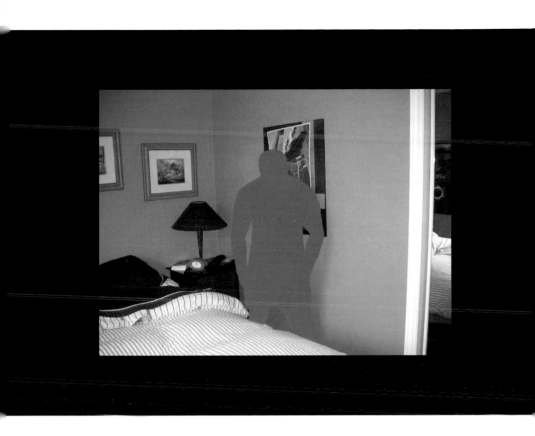

This is a more calculated approach using "Electric Iceberg," a color so cold anyone will jump into bed with you just to get warm.

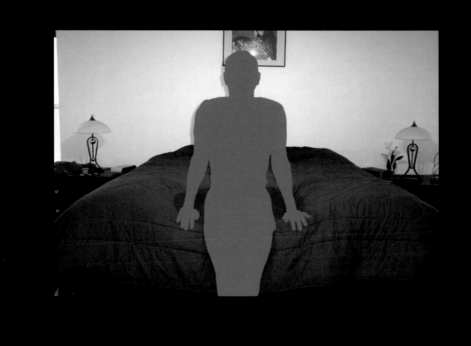

 P eople assume symmetrical arrangements will look
elegant-and that's true if the items themselves are
elegant. Crappy furnishings are crappy furnishings no
matter how they're displayed. These two unlovely
lamps would look best symmetrically or
asymmetrically arranged on a card table in the garage
with a fifty cent price tag on them.

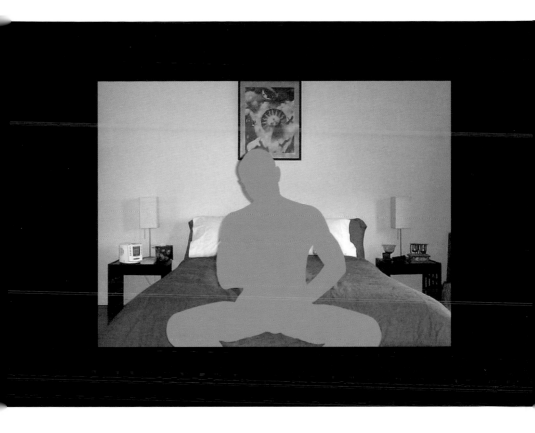

It's better, but that art is still way too small to hang over this bed. Sometimes when our friends give us things like this we feel obligated to display them. If this happens to you, sacrifice sentiment for good design and kindly tell your friend, "Thanks, but what I really need is a big horizontal mirror with a thick ebony frame to match my nightstands." A true friend will understand your priorities and respond with a Crate and Barrel gift card.

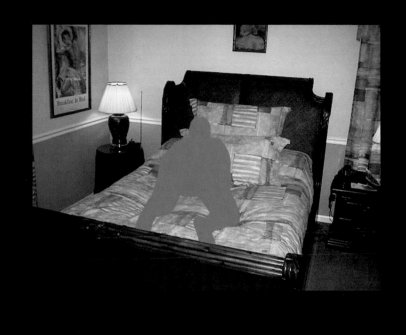

You know those friends who try to please everyone
only to end up pleasing no one? Well, the same thing is
happening here. This matching sheet and curtain set
were designed to look good with everything, but
instead look good with absolutely nothing.

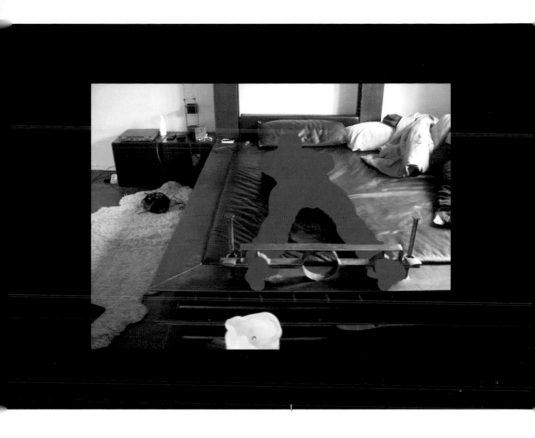

It takes a true masochist to enjoy the pleasure of leather sheets. Over time, the cleaning bills become quite painful. And, you'd better condition the leather before you use them or your sweat will leave white salt marks that will look like mildew. They demand so much care you'll practically become a slave to your own bedding.

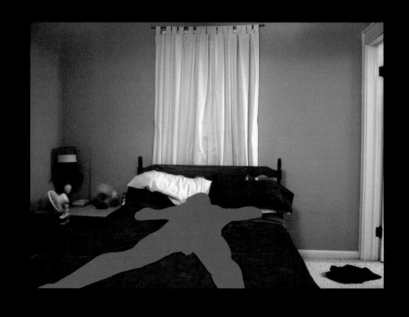

It can be exhausting finding the perfect art for your home. Most people get lazy and just buy something small and easy to carry but that's rarely what your walls need. Take the time to find art big enough to compliment the room. You can also gather several smaller pieces and display them together. A small group can be fun if it's well hung.

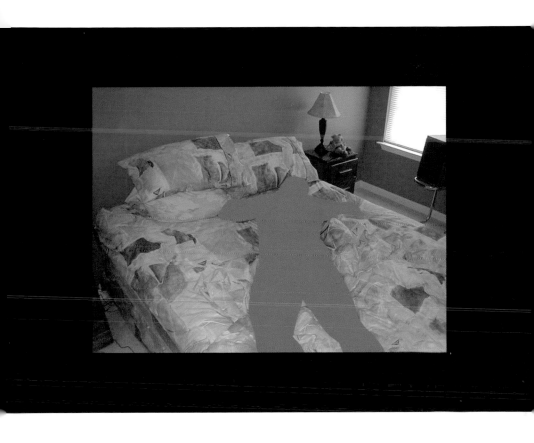

You can mitigate the burning skin irritation from cheap 130 thread count sheets by painting your walls a cooling aqua blue.

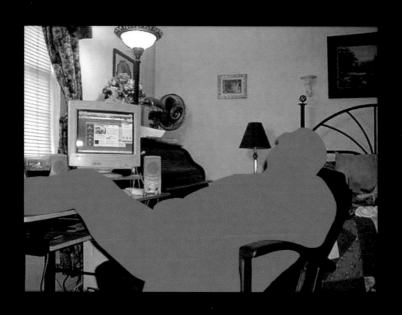

And before I go, if you insist on keeping your computer in your bedroom, I recommend installing safety filters to block access to inappropriate websites like GrannysCrap.com, or JoanieLovesTchochkies.com.

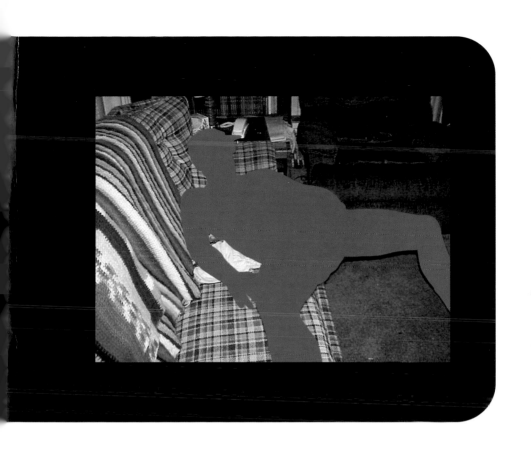

In the end, it's just a great feeling when you can relax in a space of your own design. Who really cares if the couch clashes with the carpet? So what if you like faux wood paneling. It's *your* place and it should make *you* happy. Unlike the dates you bring home, your furnishings will be around for a long time. And, I can tell you right now, my Ikea sofa has never uttered the words, "We need to talk" and my Philippe Starck chairs have never spray-painted the words, "Pussy Face!" on my car.

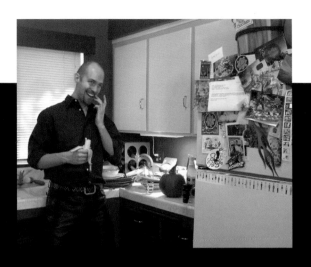

Justin Jorgensen was born on a cold gray day in Fargo, North Dakota. He is an artist who designs theme park attractions, music videos, and interiors. In 1999 he created JustinSpace.com, where his "Obscene Interiors" project began. Justin thrives in Los Angeles.